ART BY TATTOOISTS
BEYOND FLASH

Jo Waterhouse

Foreword by
Jesse Lee Denning

D0306706

Laurence King Publishing

LAURENCE KING

First published in 2009.
This mini edition published in 2012 by
Laurence King Publishing Ltd
361–373 City Road
London EC1V 1LR
United Kingdom

T: +44 20 7841 6900
F: +44 20 7841 6910
e-mail: enquiries@laurenceking.com
www.laurenceking.com

A catalogue for this book is available from the
British Library.

ISBN: 978 1 78067 018 8

Design: ON.Studio.co.uk

Front cover: **Gillian Goldstein**, Lydia *Mixed-media pen,
watercolour ink and acrylic on paper*
Back cover: **Steve Whittenberger**, Candle Man
Watercolour on paper
Page 3: **Dalmiro**, Do Or Die *India ink and liquid
acrylic on illustration board*

Contents

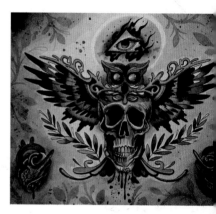

Foreword

by Jesse Lee Denning

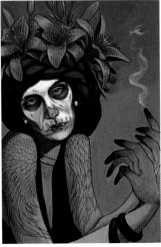

Art, in the popular view, is something that offers a pleasing or beautiful result; something that produces a desired aesthetic effect on its audience; something created by someone with a superior skill. Tattooing, on the other hand, is widely viewed as 'lowbrow', unsophisticated, even disgusting. It is seen as somewhat barbaric in contrast to the sophistication and intellectual rigour generally attributed to art. Regardless of one's position on the merits of the art of tattoo, the words themselves – 'tattoo' or 'tattoo art' are rarely held on the same level as 'fine art', at least by the public at large. It may be a reaction to this very sentiment, a move to prove such views wrong, that has prompted many tattooists to produce art outside of tattooing, and further, outside of tattoo flash and prints. Increasingly, tattooists are receiving recognition as 'fine artists', their work hanging on the walls of some of the top galleries in the world. It is a similar reaction that prompted me to encourage and curate exhibitions of the art of tattooists, exhibitions whose goal was to feature work that is not directly tattoo related.

My personal admiration and respect for both fine art – in the traditional sense – and tattooing, as well as the organic connection between the two and natural progression and flux between them, was the basis for my co-founding and operating a gallery and tattoo studio under a single roof. This, in turn, led to opportunities to curate exhibitions where tattooists exhibit non-tattoo related art, art that stands on its own merits completely outside the tattoo arena. This is not to say that typical tattoo imagery has been discouraged. However, with increasing frequency, the subject matter depicted in tattooists' art, while certainly influenced by tattoo imagery and symbolism, is looking to atypical inspirational bases beyond those of traditional tattoo subject matter. Even where the subject matter draws on traditional tattoo iconography, it is taken far beyond flash art.

Many tattooists are excited by this expansion of their creative horizon. For a lot of them, creations that were not from the realm of dragons or some form of pin-up art – i.e. imagery that is directly tattoo related – were largely unappreciated. While these preconceptions are slow to change and many people are quick to dismiss art created by tattooists, change is happening and broader recognition of such work is growing. An important component in the effort to expand acceptance of the art of tattooists is through distribution and accessibility, encouraging people to buy and collect. Even now, as tattooists look for acceptance of their own works, tattoo

themes and motifs, as well as the aesthetics of tattoo culture, are being absorbed into the traditional art world as well by traditional artists, artists who themselves have nothing directly to do with the tattoo world. Yet the particular vision of the tattooists adds a unique discipline and mindset. From still lives to sculpture, tattooists have created some of the most stunning and haunting art of our time: an art growing from a tradition of formulaic composition and skill.

Many tattooists have a formal art education background; many do not. While a formal education is not a necessary component for success, it is important to note the pull that the field of tattooing has on those who could simply have a career in the more conventional art world. One significant part of the tattoo intrigue is that it is a young, urban and creative subculture. Another is that the media of flesh and ink are so difficult to fully master, posing as they do a unique set of challenges. Whatever the reasons for any particular individual, the tattooist/fine-artist seems to be an increasingly important participant in the arts and as a result, collectors and institutions that have for many years stuck by a strict set of prescribed rules and definitions, are looking to art of tattooists and the culture as a whole.

Part of the appeal of tattooing as it was originally with much that is now defined as fine art, is that it is outside the norm: it is bohemian and cutting edge. It is also a field that separates the few truly talented individuals from the pretenders. Unfortunately, as so often occurs in the course of popularization and as the result of mass-marketing, the view offered to the public is primarily of the gritty and superficial lifestyle aspects rather than of an ancient and very difficult art form. We have here the chance not to look at reality TV as the future of tattooing, but rather to evaluate the art created by tattooists as the cultural measure of their creative world, broadening people's views so that the work is considered on its own terms, and not merely as spectacle. If the current body of work and the attention that it is receiving is any indication, future art history text books will include tattooists as part of our contemporary creative culture.

October 2008
www.invisiblenyc.com

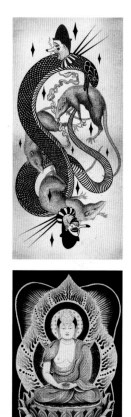

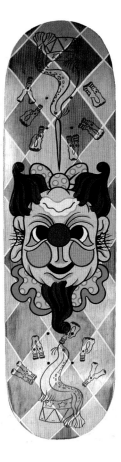

Introduction

The purpose of this book is to present personal artwork by working tattooists. There are numerous books and magazines out there dedicated to showing images of actual tattoos, but there hasn't been an accessible, affordable book before that presents tattooists as artists and showcases their personal artwork and the different forms it takes.

In the last few years tattoo culture has shifted from the fringes of society to slap bang in the middle of mainstream culture. As recently as ten or twenty years ago, the majority of those operating in the mainstream would undoubtedly have still viewed tattoos and tattooing as primarily the domain of sailors, criminals and ne'er-do-wells, football hooligans, punk band members, hairy bikers and the like. They certainly wouldn't have viewed tattoos as desirable or tattooing as aspirational, or credited the skill, creativity and artistic merit of it – which is much the case today.

Over the last 20 years media coverage of tattooing has snowballed, from the abundance of specialist tattoo magazines that now fill the shelves to the internationally popular Miami/LA Ink shows that have endeavoured to make celebrities out of tattooists and their clients. They have transported tattoos and tattooing not only to a new socially acceptable status, but also into some sort of desirable 'lifestyle choice' among members of the general population.

Whether this slide into popular culture is wholly a good thing for tattooing is debatable; there are many pros and cons and differing opinions among tattooists. The upshot though is that there is now a greater awareness, understanding and appreciation of tattoo art and artistry, even if this does mean, for better or for worse, that high-street stores are awash with tattoo-based designs on everything from clothes and jewellery to soft furnishings. These designs are usually the most obvious, classic tattoo designs and imagery – such as a swallow, cherries, anchors, etc – or are the licensed artwork of legendary tattooists such as Sailor Jerry and Ed Hardy.

There are numerous, instantly recognizable, recurring, classic tattoo designs, images and themes. Classic Western/American tattoo designs have seen a renaissance in the last decade, with people choosing to collect designs that were also popular over 40 years ago. These classic designs include hearts, skulls, panthers, eagles, the female form, daggers et al. and would have evolved from early

military/naval tattoos. There are other books dedicated to classic tattoo designs – or Flash as it is known – and there are also tattoo encyclopaedias that enable you to learn the background to designs and motifs.

Although it is relevant for me to briefly touch on the history of tattoo design, I don't need to go into the kind of detail that is readily available elsewhere. It only needs mentioning because this book is concerned with the personal artwork of contemporary tattooists and many of the artists here are inspired by, among other things, classic tattoo imagery, and reinterpret it in their own way through their artwork.

For a tattooist, the art of tattooing begins by learning a technique and style of drawing – a unique visual language derived from the bold outlines, simple, strong colours of those classic images. Creative tattooists, such as those featured here, take these classic designs and adapt and improve them, often fusing these classic elements with their own custom work.

Alongside the actual designs, there are lots of recurring themes within tattooing. One of the most common themes is death and the impermanence of life – most obviously depicted in the form of skulls and other macabre images. The struggle of life, nature and religion also feature prominently. Religious themes can be Christian symbolism like crosses, crucifixes, praying hands, the Virgin Mary, or symbols, or Buddhism imagery such as the Buddha, Dalai Lama, the Sanskrit syllable for Om, or entire mantras. Classic Japanese art and tattoo designs and symbols such as Koi, water, cherry blossom, dragons, warriors and demons are also popular. In fact, you could probably separate these main themes into just two very broad categories of life and death.

As I said, the artists here depict these themes directly or indirectly, subtly and less subtly. The tattooing connection might seem less obvious in some work, for instance in work by artists who have taken a more 'fine art' route, such as the oil paintings of Guy Aitchison, Regino Gonzales and Daniel Albrigo. With Regino and Daniel's work, however, you can still recognize the subtly depicted tattoo elements, such as snakes and skulls, and the themes of death, struggle and nature. Guy's work is subtler still, although as a highly respected and established artist his tattooing and personal artwork are completely

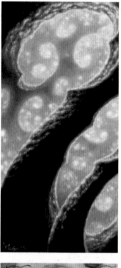

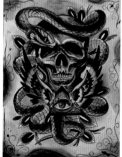

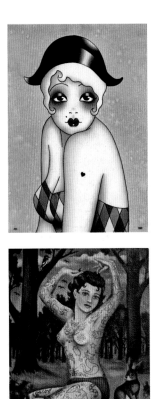

indistinguishable to himself, and people come to him specifically to have his unique artwork tattooed on them:

My tattooing and painting are not even in separate categories, as far as I'm concerned. There is too much crossover between the two mediums to make that kind of separation. Sometimes a tattoo project will inspire a painting, and vice versa. The main difference is that with painting, I can take a more elaborate vision and run further with it – skin has greater limitations than canvas.

Artists such as Angelique Houtkamp, Lina Stigsson and Carnie Marnie are clearly inspired by the past and the classic era of Western tattooing. In Angelique's own words:

Of course tattoo design is my main influence, because I use the same technique as the old tattooers used to make their tattoo flash. I am also influenced by things from the start of the last century. I just love that whole atmosphere that hangs around that period. In particular, I like the advertisements and illustration, and I've been mixing it with the tattoo style. Tattoo style is not so much the subject matter, but it's the way you execute it. Tattoo flash in the old days was done a certain way: bold lines, heavy, simple shading and a minimum of colour – leaving a lot of skin. This was because it's a fast way to make a tattoo and it would last and look good for a very long time with no flimsy details that would fade over time.

Not all the tattooists and artists featured in this book find tattooing as creative an outlet as their personal artwork. Although the majority of them are custom tattooists – tattooists who create one-off custom pieces for their clients, mostly based on their own artwork – the client's wishes remain the determining factor in their tattoo work. For instance, Jason d. Leisge feels that he is simply an illustrator when he is tattooing:

With tattooing I am essentially an illustrator; you come to me with an idea and I illustrate it for you. My work is my narrative; I am less constrained, less concerned with the final product and more concerned with the process.

Lina Stigsson also feels less constrained with her personal artwork:

When I work on my paintings it's just me and the canvas. I think that's the biggest difference from tattooing, where you are actually designing something specifically for someone. I'm really happy to be able to pursue both tattooing and painting since I like to have variety in my work.

As does Cody Meyer:

I would say that for me, my personal art is more of a creative outlet for sure. A tattoo that I do is always going to come down to my final say, but there is usually always a compromise with the client that supersedes your own vision.

Many of the tattooists featured in this book choose to work in watercolour. This is because many find it has a similar technique and look to tattooing itself, as Matt Hunt explains:

I find that watercolour is very close to the way I usually tattoo: you outline first, then put the black and grey in, and it is all very precise and neat. There is little room to correct mistakes.

The artists featured here also use a variety of media to produce their work, including oils, acrylics, mixed media and lino printing. Several of the artists are also, perhaps somewhat surprisingly, influenced by the work of the 'old masters' such as Caravaggio, Rubens, Botticelli and Van Gogh. Artists including Guy Aitchison, Mandie Barber, Daniel Albrigo, Regino Gonzales and Matt Hunt all take inspiration from classical forms of art and painting. Although at first this could be viewed as an unexpected source for tattooists, when you consider the subject and themes these old masters were painting, it is less so: life, death, struggle, religion, nature, the female form – sound familiar?

Contemporary, non-tattoo artists are now also looking to tattooing for inspiration as well. As Matt Hunt has observed:

There also seems to be more and more of an overlap between contemporary artists and tattooing now, a mutual respect and borrowing of ideas.

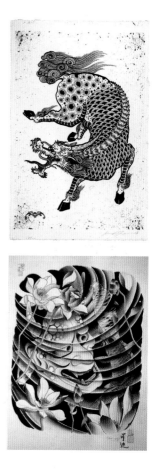

9

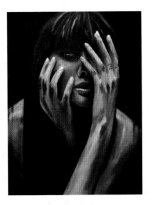

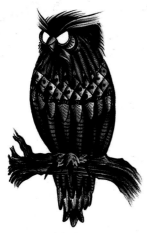

That's why it's impossible to pigeonhole these artists as 'just' tattooists or 'just' tattoo artists: they are simply artists in their own right. The themes and subject matter in their work are universal and ageless, and many are exhibiting in galleries on the strength of the artwork itself, without the need for the connection to tattooing in order to understand or validate it – the artwork stands alone. Tattooing might be particularly popular now, but this group of people will always be tattooing and creating their personal artwork regardless of whatever the popularity rating for tattoos.

As with my previous *Concrete to Canvas* books, I wanted to put together the kind of book I would love to buy myself. I've had a long-standing interest in tattooing and tattoo artwork and several tattoos myself. I haven't found a book like this anywhere, so thought it would be a fun project. As with my previous books I wanted to be able to showcase the work of a range international artists, some of whom will be recognizable by those of you familiar with tattoo culture, and some who will be completely new discoveries. Due to the size and format of the book, it is only supposed to be an introduction to each artists' work, with the deliberate inclusion of website information for those that want to take a more in-depth look at particular artists. And of course there are also lots of other artists and tattooists out there producing wonderful work that weren't able to be included here. As with the previous books, this isn't meant to be any kind of encyclopaedia; this is just the tip of the iceberg of the world of art by tattooists.

Above all, the point of this book is to show the work of a group of talented artists whose work should and does exist, and is appreciated and respected, outside of the umbrella of tattooing. As the lines between highbrow and lowbrow art, high culture and popular culture, continue to blur, more and more artists are emerging from the tattoo studio and into the gallery.

Jo Waterhouse
November, 2008

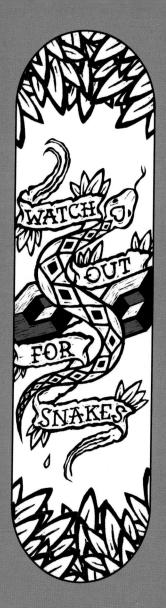
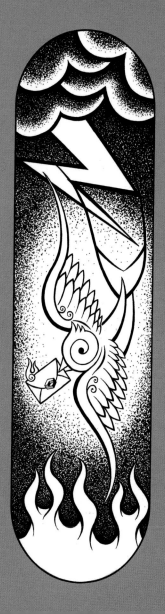

G uy
Aitchison

Guy Aitchison will need no introduction to those familiar with the world of tattooing. He is a much-in-demand tattooist and artist operating out of the private, invitation only, Hyperspace Studios in Illinois, co-owned by his wife, and fellow artist and tattooist, Michele Wortman.

Guy has been tattooing for the last 20 years. He started out in 1988 as an apprentice to Bob Oslon in Chicago. He had his first tattoo at only sixteen, which was a small green lizard of his own design.

Getting tattooed was originally suggested by my sister Hannah (also now a tattoo artist). It turned out to be a pretty good idea. As soon as I got my first tattoo I knew I wanted to become a tattooist. Simply from watching, I knew I would enjoy it and do it fairly well.

Guy enjoys the 'realness' of tattooing; that it brings about a certain focus and intensity that can't be found elsewhere. He describes his personal artwork as a direct extension of the subject matter and techniques he uses in tattooing, but is a bit more personalized and more experimental.

It's mostly what I refer to as 'concrete abstraction'. Abstract imagery that has a sense of tangible reality and realism to it. I like the notion of an impossible thing that is nonetheless presented in a believable way.

Guy uses oil and acrylic for his paintings, sometimes a mixture of the two. He also goes to great lengths to create the reference material for some of his paintings:

Often it will include sculpting some objects from clay, creating other items in a virtual 3D environment, Photoshopping them together and then projecting the whole mess on to canvas to start the piece. I think this multimedia approach has enabled me to do things that are otherwise impossible.

Guy doesn't see any creative distinction between his tattooing and artwork, they are not even in separate categories to him as there is so much crossover between the two disciplines. The two often inspire each other: a tattoo project will inspire a painting and vice versa.

I am not only an artist but have a great deal of interest in science and philosophy, and believe that the entirety of life's mysteries can potentially be understood as an aesthetic phenomenon.

www.hyperspacestudios.com

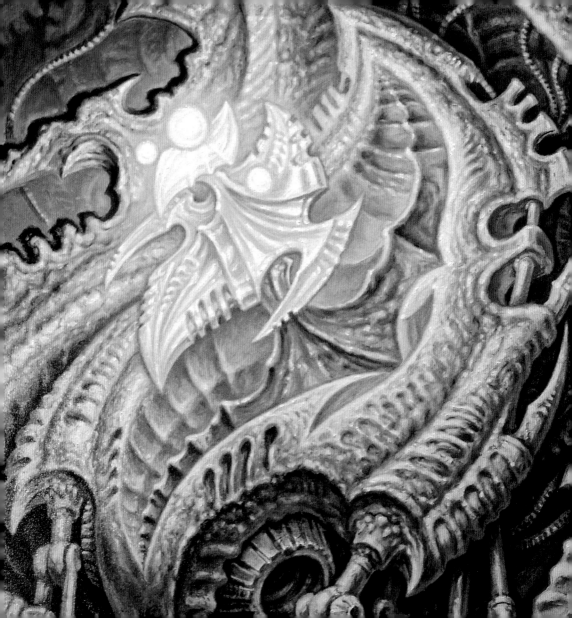

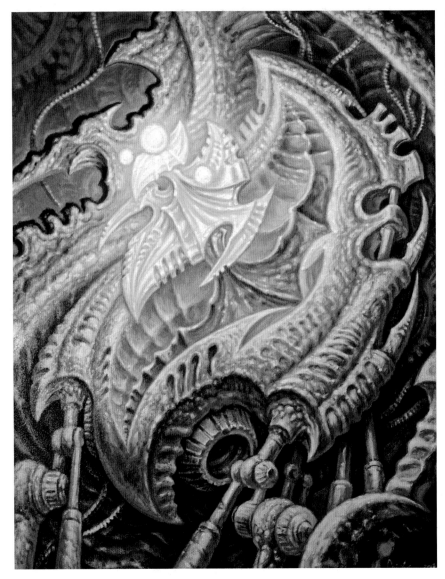

Left: **Biomech Mind Tree**
Oil on canvas

Opposite, clockwise from top left:
Lightform 10 *Oil on canvas*
RootSpace 1 *Acrylic on canvas*
AutoMech 11 (detail)

Following pages:
Live Coil *Oil on canvas*
The Lotus Unfolds *Oil on canvas*

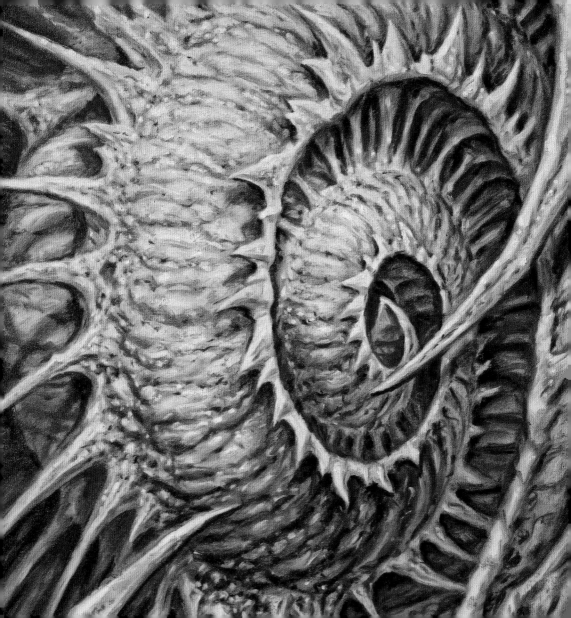

Daniel Albrigo

Daniel Albrigo works at the New York Adorned and Brooklyn Adorned tattoo studios. He previously worked at Invisible NYC, alongside fellow tattooists and artists Regino Gonzales and Gillian Goldstein. He has been tattooing for seven years and was born and raised in Pomona, California. He moved to New York City in early 2008.

Daniel took painting classes in high school to learn the basics of oil and watercolour paintings. His personal artwork takes two forms, ink paintings and still life oil paintings:

It's nice to be able to move between the different mediums, it keeps each one fresh. My ink paintings also have strong roots in tattoo designs, but on a more whimsical level. If I didn't have the knowledge of drawing designs for tattoos, my paintings would look substantially different; it has a direct influence. I am also influenced by astronomy, alchemy and celestial charts; I use a lot of constellation references because there are so many great ideas in the stars. My oil paintings are more influenced by the old masters and Italian painters such as Titian and Caravaggio and (the Flemish painter) Rubens. Lately I've been painting still life and portraits based on what I've learned from these past artists.

Daniel knew he wanted to be a tattooist when he started getting tattooed regularly himself by Matt Green, and eventually apprenticed under him for about a year before taking on the overflow work at the shop.

Nowadays more of his time is given to his personal artwork and he has taken an extra day off a week to concentrate on his paintings. He has exhibited widely in the US and in May 2009, he and Timothy Hoyer had a joint show in Tampa, Florida.

www.danielalbrigo.com
www.myspace.com/mr_albrigo

Above: **Catching Lepus** *Ink and gouache on paper*
Opposite: **Grieve** *Ink and gouache on paper*

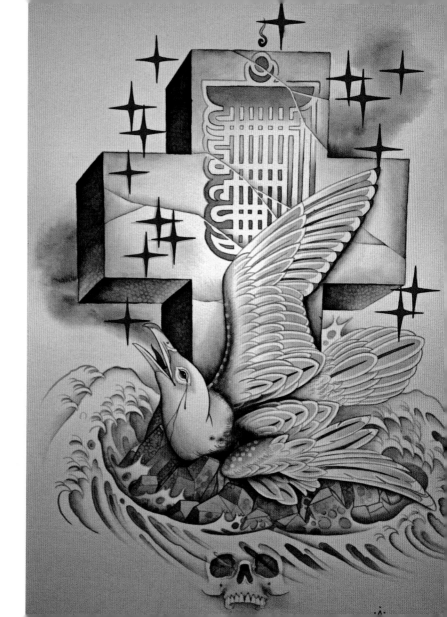

Clockwise from top left:
Occupational *Oil on wood panel*
A Usable Chasm *Oil on wood panel*
Ainslie *Oil on canvas*

Opposite: **Canine** *Ink and gel medium on paper,
mounted on board*

Mandie Barber

Mandie Barber works out of her own, private studio called True Love Tattoos in Kidderminster, UK, which she opened in 1998. She has been tattooing for the last 20 years and has built the kind of reputation and full diary that only genuine talent and hard work can get you.

Her first tattoo was at the somewhat alarmingly tender age of thirteen, from a hand-poked needle and cotton. She got her first professional tattoo at fourteen, and it was at that time that she, albeit semi-subconsciously, decided she wanted to be a tattooist:

I do remember having the thought when I got my first tattoo; it was a woman that did it and that was rare in those days. I know now that the seed was planted at that moment.

Despite having worked as a tattooist for such a long time and having a loyal client base for her custom work, it is only fairly recently that she has taken her creativity from skin to canvas. For her personal artwork, which is inspired by Classical art, love, beauty, and religion, she does a lot of pencil drawing and paints in acrylics, but is also keen to try oils. She describes her work as precise, bold and strong, yet fairly simple at this stage.

I feel like I'm just scraping the surface with my painting. I'm looking forward to developing it much further. Tattooing influences my artwork almost entirely because I've been tattooing for so long now. I've only just started painting and haven't yet allowed myself to indulge the freedom that is possible with paint and canvas.

For this reason she still finds tattooing a more creative experience as it is the discipline in which she is most experienced. She is so used to skin and ink that she always knows what results she will achieve.

www.truelovetattoos.co.uk

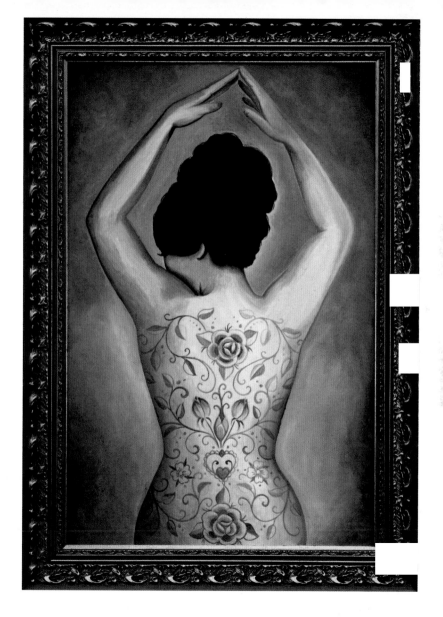

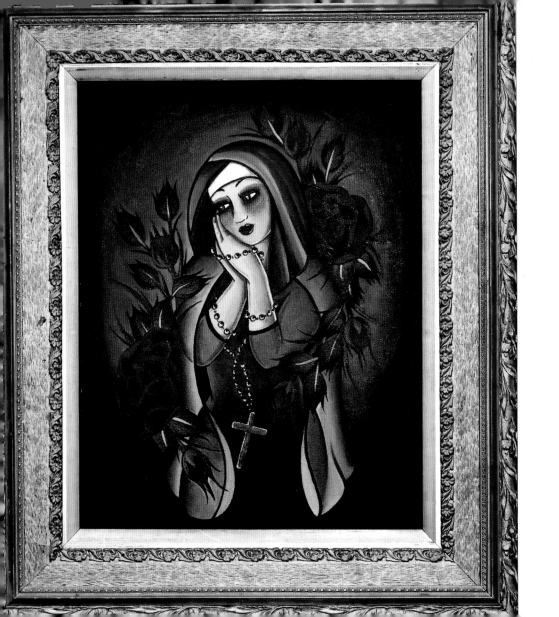

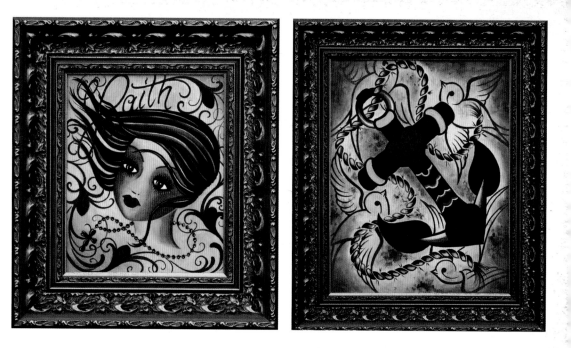

Above left: **Faith** *Acrylic on canvas*
Above right: **Anchors & Swallows** *Acrylic on canvas*
Opposite: **The Nun** *Acrylic on canvas*

E rik Von
Bartholomaus

Erik Von Bartholomaus is originally from Washington, DC, but is now based in Albuquerque, New Mexico at the Stay Gold tattoo studio. He has been tattooing for 13 years and apprenticed in Barcelona.

He got his first tattoo aged seventeen and decided to become a tattooist when several people he knew suggested it to him. His previous jobs included working in highway construction, as a courier and in office and art supplies. He describes his personal artwork as 'experiments in progress', and is inspired by animals and buildings. He mostly uses ink and watercolour to paint his pieces. He hasn't had any formal art training.

I try to paint, write and read as much as I can. It's not so much about quantity, for me the cool stuff happens only through consistent creative effort.

www.erikvonbartholomaus.com
www.myspace.com/erikvonbartholomaus

Above and opposite: **Untitled works** *Ink and watercolour on watercolour paper*

Above and opposite: **Untitled works** *Ink and watercolour on watercolour paper*

Chris Bourke

Chris Bourke trained as a tattooist in Worcester, UK, where he is still based. Chris hung up his machines for quite a while to concentrate on his personal artwork, as well as running his independent skate shop Spine. He has experimented with different mediums with his artwork, including watercolour, before rediscovering the joys of lino printing. His lino prints have appeared on skateboards and T-shirts for UK companies A Third Foot and Death, and for Consolidated Skateboards in the US.

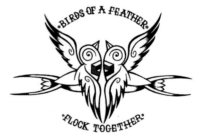

His personal artwork features a lot of classic tattoo imagery. He is also influenced greatly by his passion for music – especially reggae, as well as by nature, politics, struggle and truth.

I think it's important to keep drawing and working on art outside of tattooing. To me it's as important as tattooing itself. I strive to be original in all areas of my work. I work hard on my artwork and I hope it shows. Tattooing has become such a large part of popular culture these days. It wasn't like that when I started getting tattooed, and I feel that in many ways it's a good thing. Of course, you get a lot of bandwagon jumpers when something is popular, but hopefully the upside is more people getting tattooed and developing an appreciation for the art that surrounds it. Art is for everyone; it's not the preserve of the highbrow and university educated. It's for anyone who wants to pick up a pencil and work hard, which is what art should always be: a way of liberating yourself through creation.

In the last few years Chris has continued to tattoo friends and family, preferring the freedom of tattooing people he knows with artwork he wants to tattoo. Chris has exhibited his work throughout the UK and abroad including solo shows in London and Amsterdam, and has been featured in several art, skateboard and tattoo magazines. When he's not tattooing or printmaking, he can usually be found on his skateboard – his other lifelong passion.

www.chrisbourkeart.com

Above: Birds of A Feather (design for Consolidated Skateboards)
Ink and Photoshop
Opposite: Sail On *Lino Print*

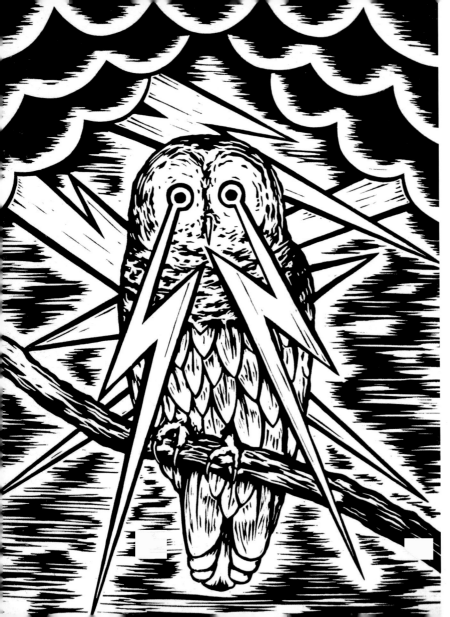

Left: **Owl** *Lino print*

Opposite
Left: **Anna Fur Laxis** *Lino print*
Right: **Love it, Hate it, Skate it**
Lino print

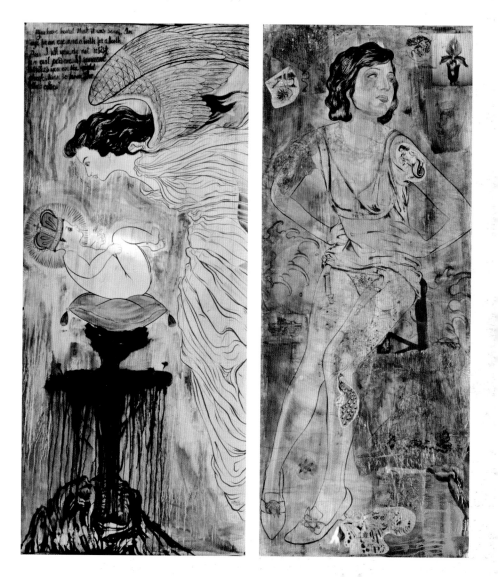

Below left: **Angel Son** *Sumi and acrylic on cold pressed watercolour paper*
Below right: **Anna E** *Sumi and acrylic on cold pressed watercolour paper*

Below left: **Punk Girl** *Sumi and acrylic on cold pressed watercolour paper*
Below right: **One** *Sumi and acrylic on cold pressed watercolour paper*

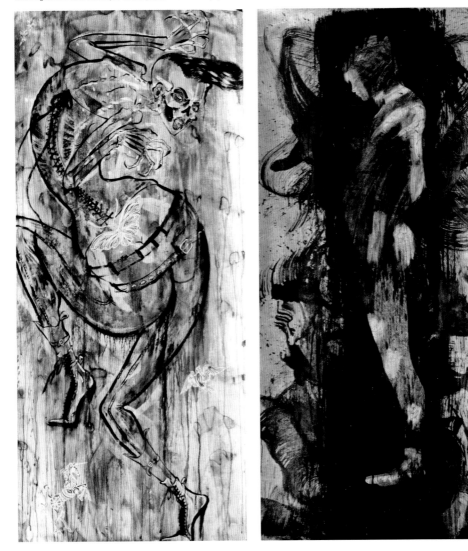

Below left: **Two** *Sumi and acrylic on cold pressed watercolour paper*
Below right: **Three** *Sumi and acrylic on cold pressed watercolour paper*

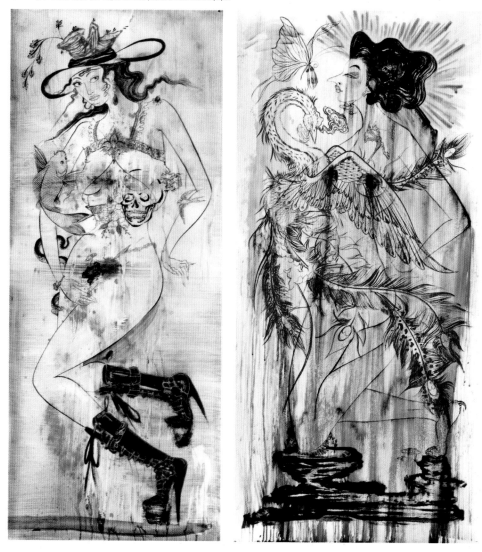

Dalmiro

Dalmiro is originally from Buenos Aires, Argentina but is now based in Sweden. He has been tattooing for seven years and now works at South of Heaven custom tattoo studios in Västerås, which is a large, private, appointment-only studio.

Before becoming a tattooist, Dalmiro spent long days at the beach surfing and working wherever he could to fund his travelling. He has fond memories of these years when he was able to 'go with the flow'.

He got his first tattoo at only fifteen years old:

I was pretty young! The funny thing was that I just walked into a shop and I told the guy what I wanted to have. He just said okay, give me five minutes, no ID, no rules. I got a little logo from the Alice In Chains band! Such nice memories! But as soon as I got a machine in my own hands I knew that it was a very special thing to do. It took me three years to get my mind and equipment together after that first love I felt; that was sometime in 1999.

For his personal artwork Dalmiro mostly used ink and watercolour on thick watercolour paper. He believes you can clearly see that his paintings are made by a tattooist due to his strong bold lines and powerful contrasts. He likes to use colour, but mostly he uses a big, solid black base as black is his favourite colour.

I have found that the thicker the paper is, the smoother the result will be. I rarely sketch directly on the watercolour paper because it's quite easy to scratch it with pencil. Plus if you use an eraser, it will destroy the surface, texture and consistency of the paper. Once you have the final sketch, it's good to use a light box, or table put over the light, and redraw the sketch on to proper paper. After that you have it clean and wonderful to start on with your brushes. I consider myself a 'brush guy', instead of a pencil one.

I just feel like this is just the beginning of a long journey. I consider myself a new tattooist. I think it's very important to have certainty and discipline; you may have a natural talent but without exercise and hard work it is wasted. In my case I don't think I have a natural one. Recently I started getting more comfortable with my own work as a tattooist and painter, and I feel I am achieving better and better results.

www.myspace.com/dalmont

21 Grammes Soul *Acrylic on illustration board*

Insomnia *India ink and liquid acrylic on illustration board*

La Reina *India ink and liquid acrylic on illustration board*

Time is Gone *India ink and liquid acrylic on illustration board*

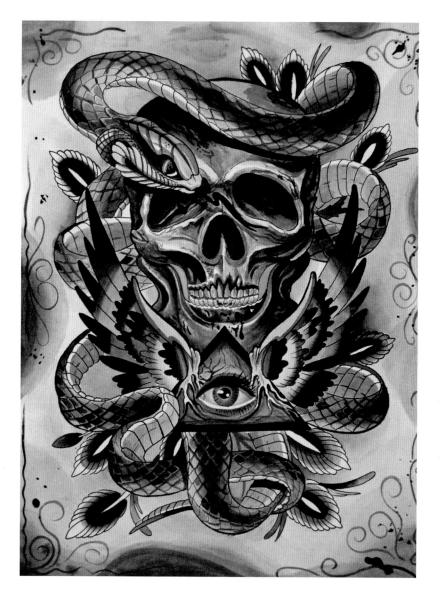

Pesadillas *India ink and liquid acrylic on illustration board*

Nate
Diaz

Nate Diaz is from Florida and had
been working at Rock-A-Billy Tattoo
in Lauderhill for nearly ten years. He
is now on the road. He has had no
formal art training, but worked as
an apprentice tattooist under Lance
McLeod at Devotion Tattoo in
Orlando, Florida.

For his personal artwork he works in watercolour, liquid
acrylic and gouache. Although he is heavily influenced
by tattoo art and imagery, he finds it hard to describe
his own artwork:

*I am the worst critic of my art; I leave it to others to give
me feedback. After all it's personal taste. I try my best
and hope that the viewer gets something from it: good,
bad, or indifferent.*

Nate is influenced by everything around him, anything
that he sees or reads can spark his imagination. Artists
that have had the biggest impact on him include Chad
Chesko, Nick Wagner, P.L. Serrano, Nic Montgomery
and Bert Krak.

*I am who I am because of the people around me; they
make it an interesting world to see. I'm a father of two:
Jayden and Mena, and I'm married to Jen Prusinski. They
are the most supportive people in my life! As far as my
work is concerned, it is what it is and I hope you love it
or hate it.*

www.myspace.com/margatepapa

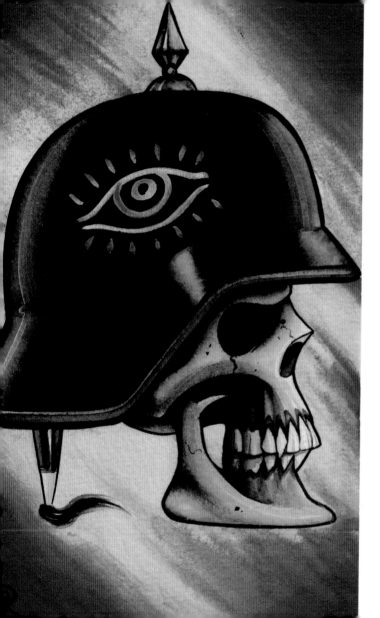

For Bert Krak *Watercolour, liquid acrylic and gouache on paper*

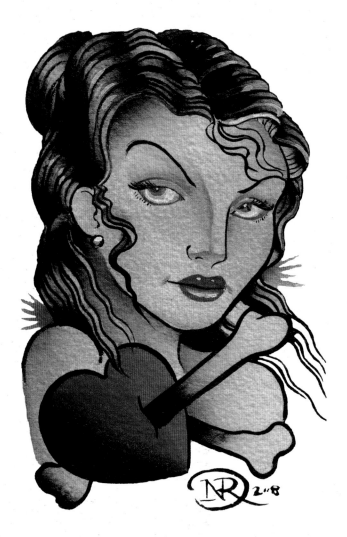

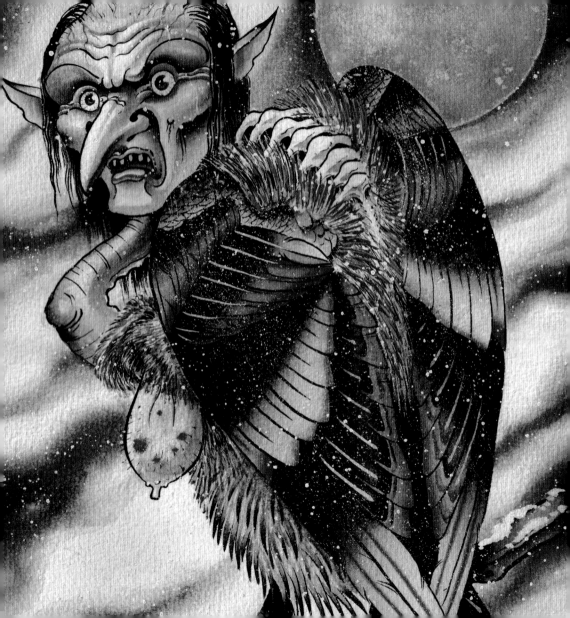

Lola Garcia

Lola Garcia has worked at the LTW tattoo studio in her native Barcelona, Spain for the past 12 years, but has only been tattooing there for nine. Before she began tattooing she took a Fine Art degree at the University of Barcelona. She has experimented with illustration, painting and airbrush techniques in her personal work, but her medium of preference is watercolour.

It's hard to describe, but basically what I'm doing is my interpretation of the traditional American tattoo art style. But I use more colour, so I am not a purist. I am also greatly influenced by Mexican Chicano culture and art.

www.myspace.com/lolagarcia
www.fotolog.com/lola_ltw

What Lola particularly likes about tattooing is that it is permanent, forever. There is no room for mistakes. She also enjoys the day-to-day dealing with people and the relationship that is established between the tattooist and client.

There is a magic surrounding tattooing. The tattoo world is exciting and the tattooists I've met are very special, unique people. In tattooing I enjoy the freedom to work in my own way and style, and the interesting opportunities to travel the world and meet other tattooists and exchange ideas.

One of Lola's biggest influences and teachers is her brother, fellow tattooist and artist Tomás García (www.inupie.com). Others who she has a particular admiration for include Grime, Dr Lakra, Dan Higgs, Erik Von Bartholomaus and Theo Mindell.

Vlad Tepes as DRKLA *Watercolour on paper*

Guns 'n' Roses *Watercolour on paper*

LTW Hipnozer
Watercolour on paper

Gillian Goldstein

Gillian Goldstein has been tattooing for two years and is apprenticing under Regino Gonzales at Invisible NYC. A native New Yorker, Gillian studied illustration at The Academy of Art University in San Francisco.

She had her first tattoo at seventeen by 'some guys at this shady spot in Chelsea', and she knew she wanted to be a tattooist after 'about half an hour of hanging out with those guys'.

With her personal artwork she works in graphite, watercolour, inks and acrylic, and her subject matter now reflects her growing confidence in tattooing.

My artwork has been recently quite a bit influenced by tattooing. Now that my studies are more focused in that direction, I try to incorporate elements of tattoo that I think will complement the piece. I feel like tattooing has enriched my drawing and painting ability as well as made me more enthusiastic about my personal work. However, there are fewer limitations when working on your own than on skin. I often use the female form to depict a psychological state that translates into iconic images. This inner turmoil seeps up through her skin and sprouts from her mind. It is my observation that in life, how one may appear on the exterior has little to do with what is truly going on in the interior. The work is a combination of those two worlds coexisting, but with a transparency as well as the acknowledgment of being revealed.

www.myspace.com/jems1

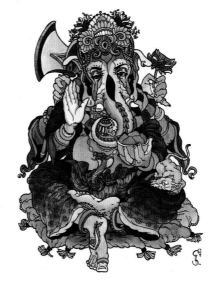

Above: **Ganesh** *Mixed-media pen, watercolour ink and acrylic on paper*
Opposite: **Mother** *Mixed-media pen, watercolour ink and acrylic on paper*

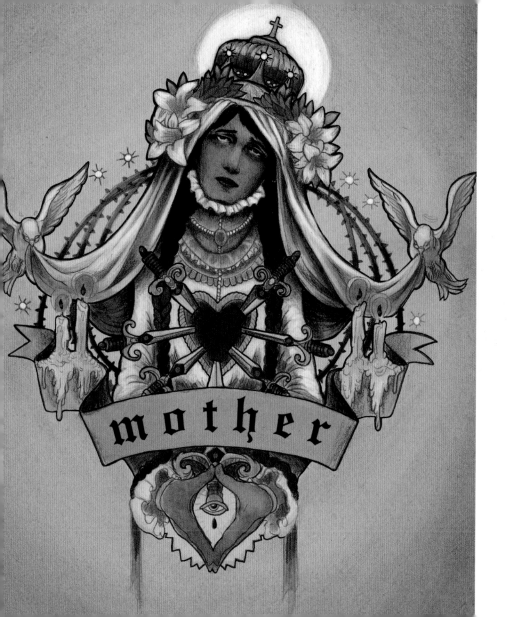

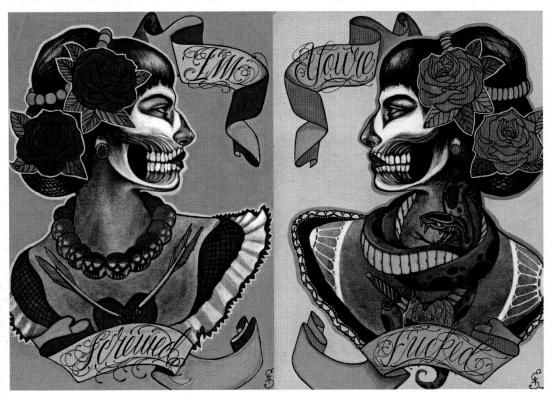

Above left: **I'm Screwed** *Mixed-media pen, watercolour ink and acrylic on paper*
Above right: **You're Fucked** *Mixed-media pen, watercolour ink and acrylic on paper*

Opposite: **Flight** (detail)

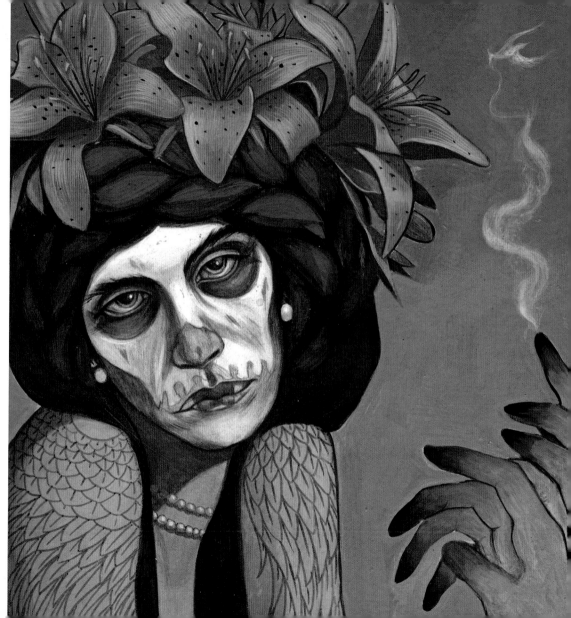

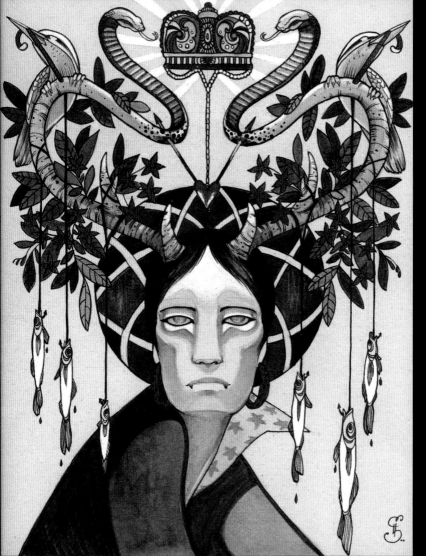

Trophy Wife *Mixed-media: pen, watercolour ink and acrylic on paper*

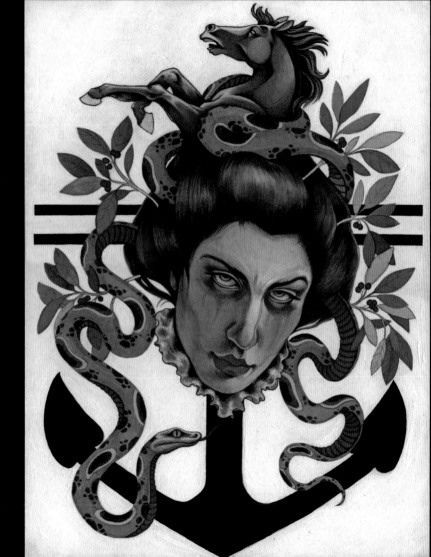

Anchor *Mixed-media pen, watercolour ink and acrylic on paper*

R egino
Gonzales

Regino Gonzales was born in Manila and raised in California. He is now based in Brooklyn, New York and works at Invisible NYC. Regino attended the School of Visual Arts in New York, one of the leading US colleges for art and design, where he gained a BFA in Illustration in 2001.

He got his first tattoo at fifteen and in 1995 went on to apprentice at the Inland Empire tattoo studio in California under Dan Adair. Before he started tattooing, he worked as a petrol station attendant on the graveyard shift.

He says that tattooing influences about 30 per cent of his personal artwork, which he finds more creative than tattooing because 'you are not being art directed by your canvas'.

Regino is talented in several disciplines and across several mediums. He is as much an accomplished graphic designer and illustrator as he is a painter. For his paintings he uses mixed media, dry mediums and wet mediums – whatever works best for the piece. He's inspired by life, friends, history and the things around him. His favourite artists are too many to name, but he loves art history in general, from ancient to the present day.

My work is based on loose narratives and personal icons in one cohesive format. It is mainly a creative outlet I pursue outside of tattooing with hopes of living off it someday and have tattooing be my outlet from painting.

www.regnyc.com
www.reginognyc.com

Above: **Cobras, Rats and Clown** (detail)
Opposite: **Untitled** *Mixed media on paper*

Following pages: **Two Cobras** *Mixed media on paper;* **Snake** *Mixed media on paper;* **Cobras, Rats and Clown** *Mixed media on paper;* **Pigeon** *Mixed media on paper*

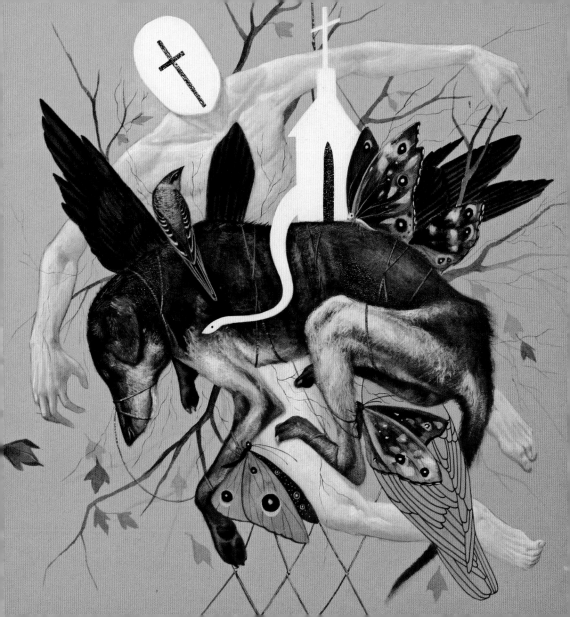

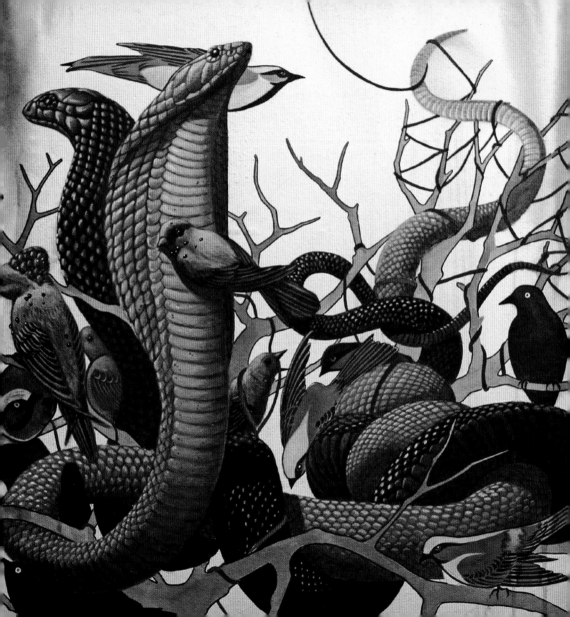

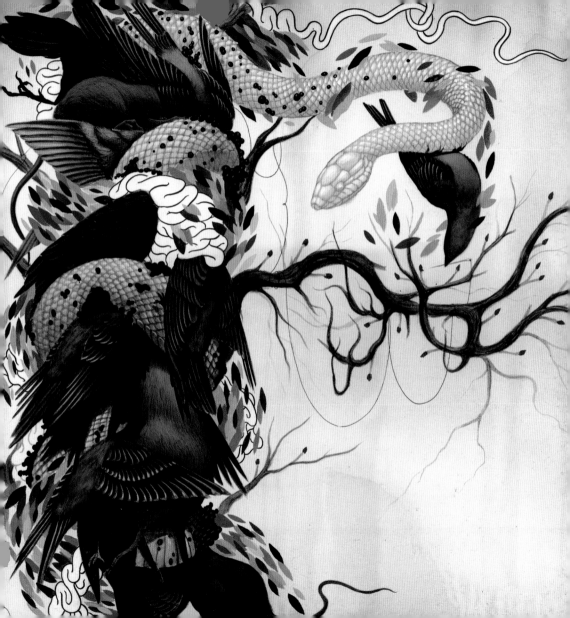

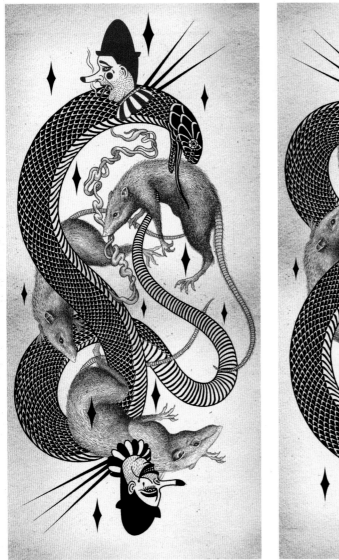

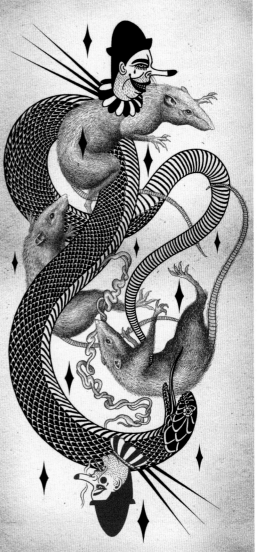

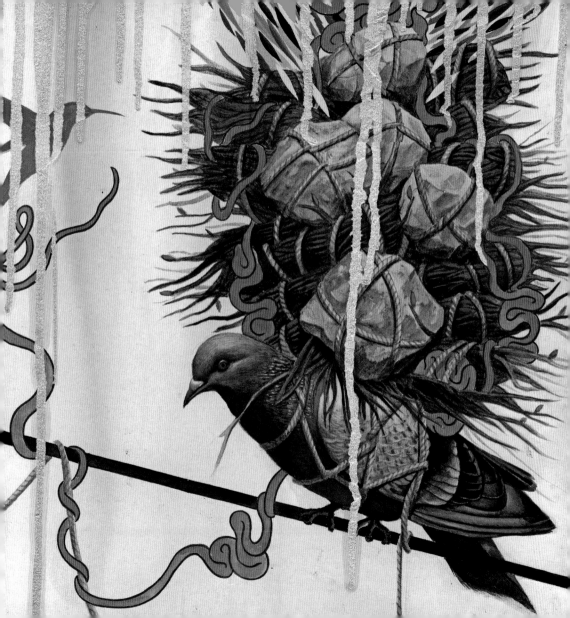

Angelique Houtkamp

Angelique Houtkamp's work is inspired by classic, old school tattoo designs. She gives her work a humorous, vintage feel with a deliberate hint of melancholy.

My work is very tattoo influenced for sure. The past year or two I feel I've also been drawn to other styles, like early-last-century advertisements and illustration and I've been mixing it with the tattoo style. The thing with the tattoo style is that it's not so much the subjects I choose, but it's the way you execute it. I am very drawn to a sort of mystery, cynicism and melancholy and I'll put that in my paintings. I don't want to make just a pretty girl's face; I want people to slightly wonder if her expression is a good or a bad thing.

Angelique has been tattooing for ten years and tattoos at Admiraal Tattoo Studio in her home base of Amsterdam. She had her first tattoo when she was nineteen – an Egyptian Scarab beetle on her shoulder – and decided shortly after she wanted to be a tattooist. It wasn't until she was thirty that everything eventually fell into place and she was able to pursue it as a career. It was around the same time she also began painting. Technically she prefers working on paper to skin, but creatively and emotionally she can't choose between the two as they both have pros and cons.

I can't help but say I prefer canvas and paper over skin. The main reason is that they are always constant; it's practically always the same. The paper could be a little dryer or older and the canvas a bit cruder or finer weaved, but you know exactly what to expect from it and what the results will be. The same goes for the paint and your brushes. With skin you don't have this; skin can be very different on different people at different times. The cool thing about painting is that you can make whatever you want without having to make alterations to please your customer. Or you can make something that turns out to be crap in the end. You can't do that with a tattoo, you don't get to throw it away if you're not happy.

www.salonserpent.com

Above: **The Girl I Love** (detail)

Below left: **Katherine** *Ink and watercolour on paper*
Below right: **Sweet Heaven** *Ink and watercolour on paper*

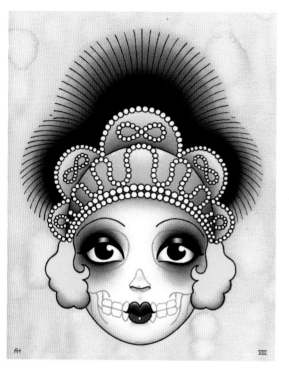

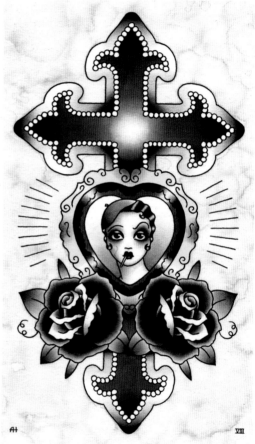

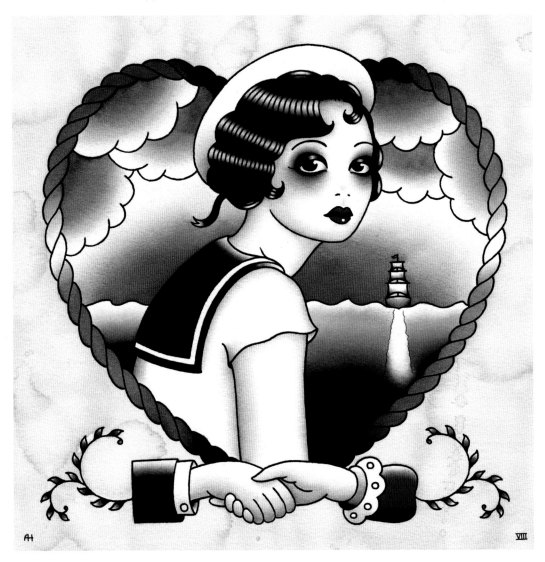

Below left: **Arlecchina** *Ink and watercolour on paper*
Below right: **The Girl I Love** *Ink and watercolour on paper*

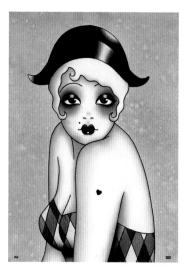

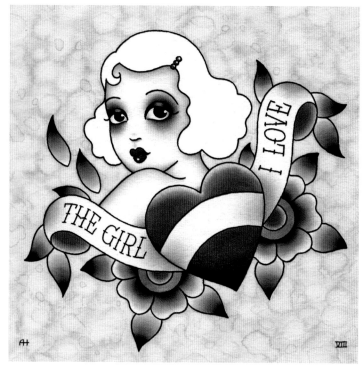

M_{att} Hunt

Matt Hunt co-owns Modern Bod Art tattoo studio in Birmingham, UK, with Jo Harrison, which they opened in 1999.

He started tattooing shortly after opening the studio, but stopped for a few years and concentrated on the day-to-day running of the business.

I felt that my potential as a tattooist was very limited and it was easier for me to concentrate on running the shop while Jo tattooed. Over the following years I had a significant change in my attitude, specifically about the nature of talent and potential. I then started to realize that the people who appear the most talented at something are, almost without exception, the people who work the hardest at developing it. I started working to improve my artwork and then started tattooing again in 2006, and continue to work hard trying to improve all the time.

Matt enjoys painting in oil but also in watercolour, the process of which he finds similar to the act of tattooing:

I find that watercolour is very close to the way I usually tattoo; you outline first, then put the black and grey in and it is all very precise and neat and there's little room for mistakes. I think it's because of this that I prefer painting in oils. I find it a real break from the day job, but luckily you still learn things that are transferable to tattooing.

Matt is inspired by artists such as Jeff Gogue, Robert Hernandez, Sabine Gaffron and Paul Booth, as well as traditional painters such as Lucian Freud and Jenny Saville.

www.modernbodyart.co.uk
www.myspace.com/matt_hunt_

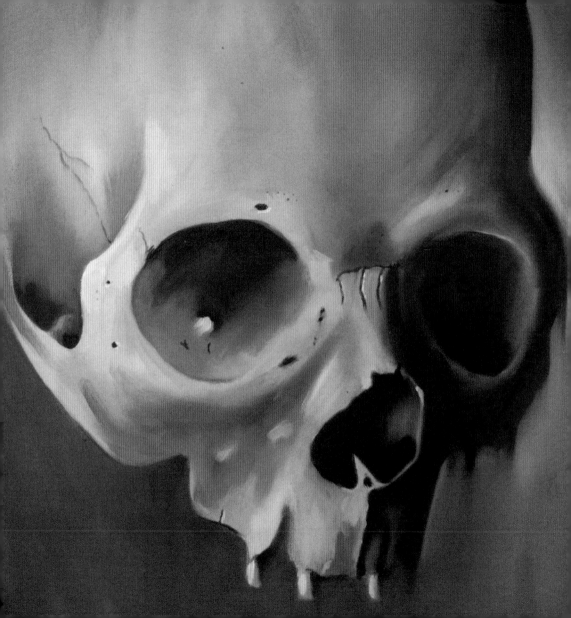

Blue Peony *Ink and watercolour on paper*

72

Koi *Ink and watercolour on paper*

Chance Isbell

Chance Isbell is from Jacksonville, Florida. He has been tattooing for nine years and works at Inksmith & Rogers, where he also apprenticed under Nick Wagner and Doren Clifford.

I knew I wanted to be a tattooist when I saw how much of a challenge it was. I saw people doing great work that I knew in the industry and wanted to try it out myself. It can be quite rewarding I'd say.

Chance mostly works in watercolour and describes his artwork as 'spontaneous', because not much planning is involved in most of it – it's mostly whatever is on his mind at the time. He finds his personal artwork just as creative as his tattooing:

I think they both have their place. I do like the fact I can walk away from a painting and work on it a few hours later though. I love when you can find similarities in painting and use it in tattooing and vice versa. I guess to me it's just a whole other pool of knowledge to draw from and use towards getting better at your art.

One of his biggest inspirations is his young son Jonah. He also finds input from other artists helpful:

It helps out a lot. I like seeing really nice shading or texture in a tattoo and going home and sketching around with those ideas in mind. I just try to be well rounded. I try not to do anything I know I'm no good at. I'll work those out on paper if I can.

www.myspace.com/chancetattoos

THANKS
JUSTIN

Chance 07

75

TO:
BERT
KRAK

Thanks
for all
the
magical
moments.
- ♡ Chance -

Think Paul Rogers *Watercolour on Arches block paper*

J ondix

Jondix got his first tattoo 17 years ago, which was an autograph of Steve Vai after he had signed his arm. He has been working at LTW in Barcelona for the last five years, which is also where he learned the craft from his colleague Tas. Before that he studied architecture at university for seven years.

Jondix finds inspiration for his personal work in everything, from Black Sabbath, Paul Laffoley's artwork to old Tibetan furniture.

www.holytrauma.com
www.myspace.com/jondix

Everything I paint could be considered tattoo flash. Lately I always use a mixture of watercolour and acrylics, that's what I'm used to. The paintings can really go to other dimensions. It's true there's more freedom [in painting], but if I can prepare the tattoo with enough time, then sometimes the result can be as innovative and even more creative than the painting.

Jondix loves Buddhist imagery and exploring the battle between good and evil. He avoids shiny colours and likes detail in his work.

I think everything I paint is to please my so called 'ego', to show to my close friends and 'try' to impress them, you know? Otherwise we will not even sign the paintings, like Tibetan artists don't. Maybe this is like this because I always work alone and I have this feeling of isolation and solitude. But all this is just another illusion of the wheel of life.

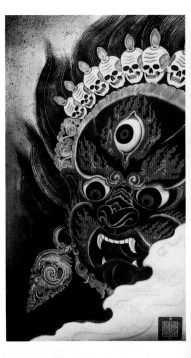

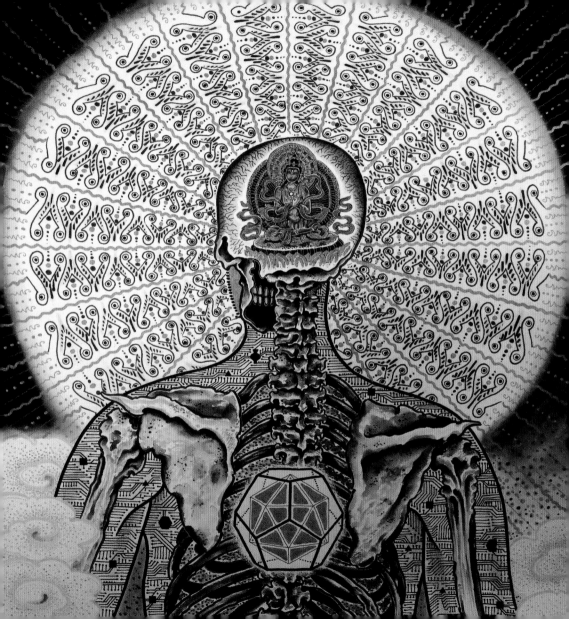

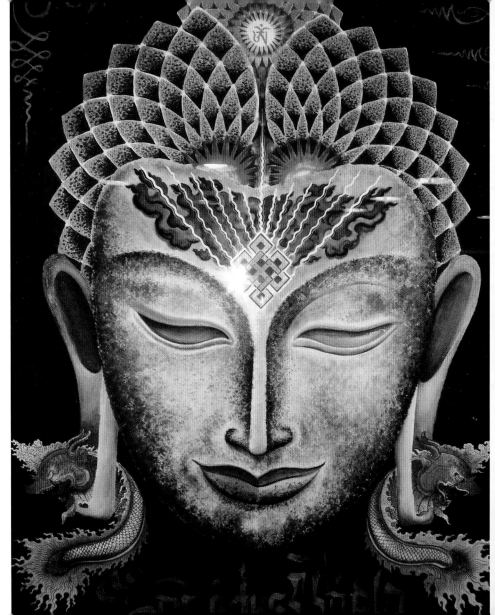

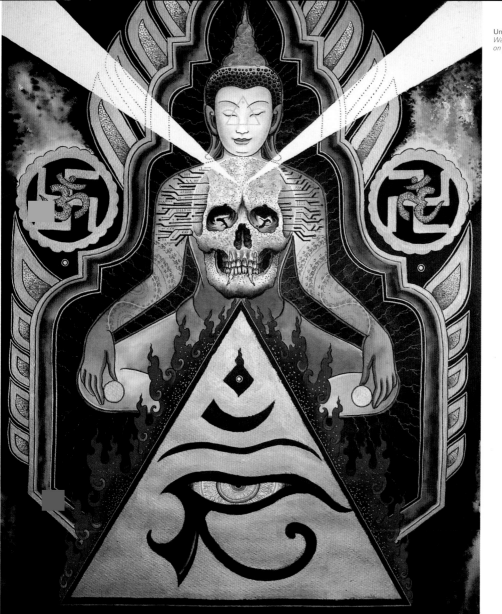

Jason d. Leisge

Jason d. Leisge is part-owner of Oddball Studios in Portland, Oregon. He is originally from the Midwest and got his first tattoo when he was eighteen or nineteen, at Scary Gary, Indiana by Famous Leg Greg. He remembers it vividly and it wasn't long after that when he knew he wanted to be a tattooist himself – he was hooked.

He has been tattooing for over 15 years and is self-taught, apprenticing in his living room. What he loves about tattooing is the freedom, friendship and, most of all, the tattoos themselves.

Jason spent a couple of years at The American Academy of Art in Chicago, where he studied oil painting and says he has always been an artist of one sort or another. He describes his personal artwork as loose:

I spend way too much time every day trying to stay in the lines and make stuff solid; that is the last thing I want to do when I am not tattooing. I like having mood and emotion in my work. Tattooing influences everything for me though; even if it's not direct, it's in there. With oils the influence is hidden; my watercolours are all about tattooing.

As well as oil and watercolour he also works with acrylic and house paint – whatever he needs to achieve the desired effect. He finds his personal art more creative than tattooing.

With tattooing I am essentially an illustrator, you come to me with an idea and I illustrate it for you. My personal work is my narrative. I am less constrained, less concerned with the final product and more concerned with the process.

Jason is inspired on a daily basis by life in general, his wife and daughter, and by the people he works with. Dedication to anything inspires him.

I am and have always been interested in people and our relationship to the outside world, or the world outside ourselves. Through personal introspection and observation my work is a documentation of my discoveries – my interpretation of the world outside of myself.

www.jasondleisge.com
www.oddballstudios.com
www.myspace.com/jasondleisge

Below left: **Kirin** *Acrylic, watercolour and gold on paper*
Below right: **Baku** *Watercolour on paper*

Coils *Oil on canvas*

C arnie
Marnie

Carnie Marnie has been on the road for several years, making the most of the travel opportunities tattooing has presented to her. She has worked as a guest tattooist at several studios in North America and Europe.

She is originally from a small town in northern Ontario, Canada but has now made her home base in Geneva, Switzerland, where she opened her own private studio earlier this year.

Marnie was awarded a scholarship to study a degree in visual art, but it wasn't long before she dropped out:

When at the tender age of nineteen I mentioned to my drawing professor that I was interested in tattooing, I was met with raised eyebrows about this 'lowbrow' business (as if the world of 'high art' is any less of an industry). It seemed incredible that I should pay an institution to have a subjective opinion.

Carnie Marnie has exhibited throughout the US and Canada and her personal artwork reflects her love of classic tattoo designs. There are two main recurring themes, the female form and carnivals. And then there is the combination of the two – bearded ladies crop up on a regular basis.

My personal artwork is ultimately a reflection of my love for occidental tattoo flash. This vast and perpetually evolving visual language never fails to intrigue me. The style and subject matter of the tattoo world always serves as a framework whether I paint on toilet seats, shoes or Arches paper.

www.myspace.com/tattooerpainterdingdong

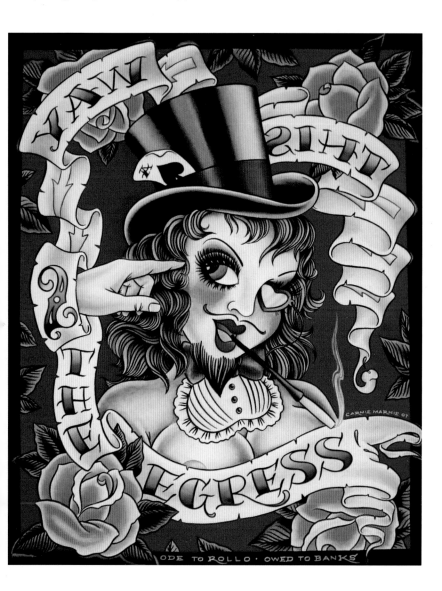

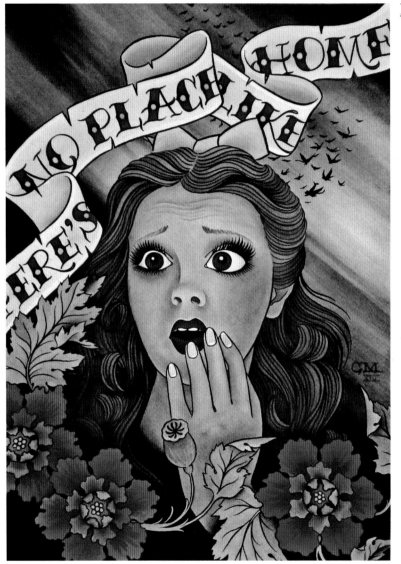

There's No Place Like Home *Acrylic ink and watercolour on paper*

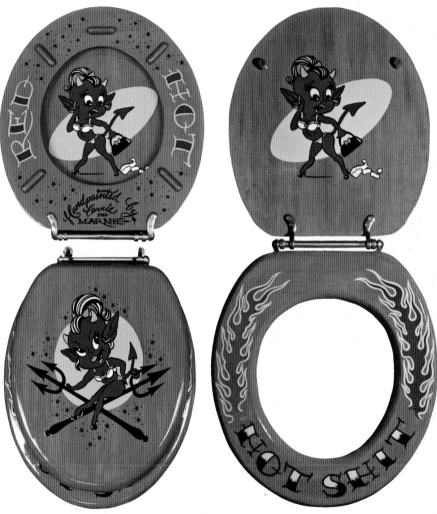

Cody Meyer

Cody Meyer works at Aces High Tattoo Shop in West Palm Beach, Florida. He is originally from South Dakota, and has been tattooing for just over six years.

I didn't have what you'd call a formal apprenticeship. After many failed attempts and very long stories, I ended up taking a loan out against my car to buy a kit online. After ten-hour days at my 'real' job at a small machine shop, I'd come home to my spare bedroom which I converted into a beginner's studio. In the end, my legs, stomach and one arm tell the tale of my apprenticeship.

Before he became a professional tattooist Cody had a vast array of jobs: everything from pizza delivery driver, forklift operator and roofer to newspaper columnist. The last job he had before becoming a tattooist was setting up irrigation pivots in the middle of cornfields.

Cody has a Commercial Art Degree from Nossi College of Art, Nashville. Although he has been drawing since childhood, he says he only began painting seriously four years ago and still considers himself a student of the craft. His personal artwork is directly influenced by his tattooing and vice versa:

Since becoming a professional tattooist, it has, of course, directly influenced my own personal work and style. But it goes the other way also; I paint, like so many of us, in watercolours, which in my opinion very closely simulates the process of a tattoo. So doing it often and becoming better at it directly influences your tattooing style too. There is no doubt that I've become a much better tattooer because of painting.

Cody is inspired by and drawn to traditional Japanese artwork, painters and tattooists which is reflected in his own artwork.

I have always been inspired by Japanese culture in general – past and present. They intrigue the hell out of me. It's just such a unique, beautiful and rich place; I'd love to go there someday. I am inspired by all the great Japanese tattooers, from Horioshi to Shige. There are too many to list. To put it simply – I admire the ones that know what they love and what they do best and just do it.

www.myspace.com/codyoshi
www.aceshightattooshop.com

Rocketqueen
Watercolour on paper

Right: **Up the Falls** *Watercolour on paper*
Far right: **Agent Skully** *Watercolour on paper*

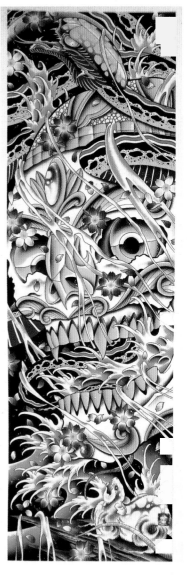

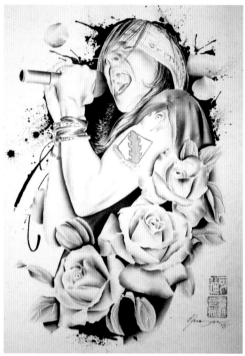

Above: **Axl** *Watercolour on paper*
Left: **Foo Dog Girl** *Watercolour on paper*

D erek
Noble

Derek Noble is originally from Bellevue, Washington, but is now based in Seattle and works at the Lucky Devil tattoo parlour on 12th Avenue.

He was seventeen when he got his first tattoo and nineteen when he seriously started considering it as a career. He played football for Western Washington University where he got his degree, and started a tattoo apprenticeship while still at University – in between studying and playing football.

Initially tattooing didn't necessarily influence his personal artwork:

Once people began asking me to tattoo stuff on them that I had painted I started to wonder if my paintings would work as a tattoo. Now I pretty much paint the same way I tattoo. I work mostly with watercolour, sometimes oils. I want to start using more stuff though, try to be a little more creative.

Derek's influences include music and books. He also really likes imagery associated with the occult, witchcraft and horror movies. He thinks the darkness of his work comes from his love of 'creepy shit' and a dislike for the Christian church.

He finds painting somewhat more creative than tattooing:

There are no limits when you're painting; you can do whatever the hell you want and use whatever you want. You don't have to make anybody else happy but yourself.

www.myspace.com/dereknoble
www.dereknoble.fatzombie.com

Above: **Jesus Saves** (detail)

Below left: **Goathead** *Watercolour on paper*
Below right: **Horselady** *Watercolour on paper*

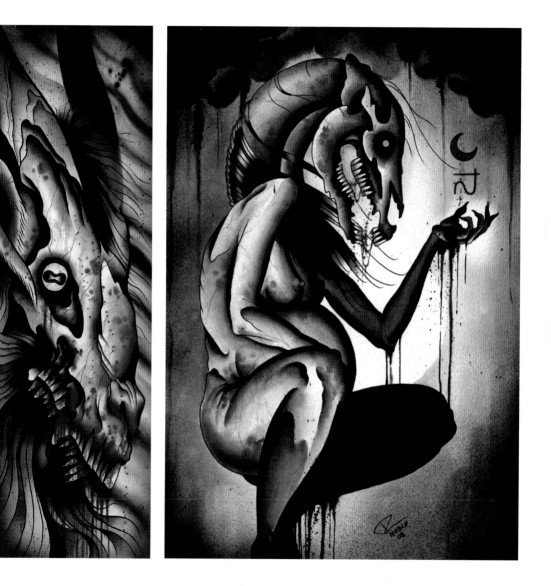

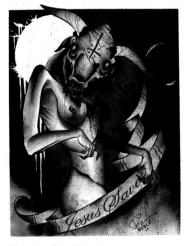

Above: **Jesus Saves** *Watercolour on paper*
Right: **Two Headed Swan** *Watercolour on paper*

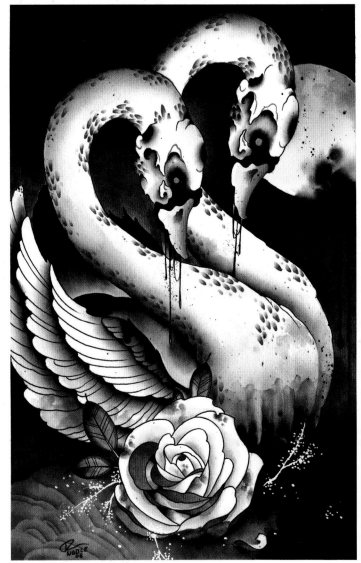

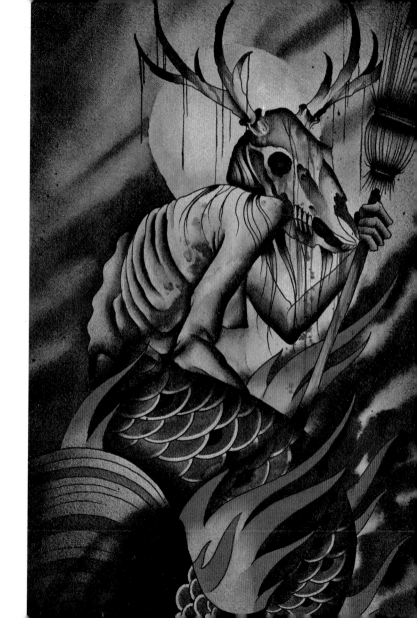

Deerwitch *Watercolour on paper*

Lucy Pryor

Lucy Pryor works at Into You in London. She's originally from Staffordshire and studied textile design at university. She got her first tattoo at eighteen and knew from then on it was something she would end up pursuing herself, although it took a few years to get there.

I've always followed an artistic path and once I started getting tattooed I started investigating the possibilities of an apprenticeship. This was a long and sometimes frustrating process which eventually led to my apprenticeship when I was twenty-five.

Her personal artwork is inspired by her love of traditional, religious artwork and iconography, and she is often drawn to the themes of saints and sinners and has a passion for bold colours. Her work is also inspired by vintage horror, Victoriana and classic pin-ups.

I always seem to think as a tattooist even when I'm doing my personal work; it's unavoidable but I think the two complement each other. When tattooing, I'm concentrating on being prepared and being as precise as possible. I can be a lot more impulsive when I'm painting. Both are ultimately creative, but have a different feel.

Lucy has now been tattooing for nine years and particularly enjoys tattooing her own artwork on to clients:

I am now in a position where I mainly do custom work. It's a great feeling tattooing your own artwork/style on to someone. Also the freedom that tattooing allows me to travel with my work. I'm fortunate to have a job that I love and that allows me my freedom in so many ways.

www.myspace.com/lucy_pryor
www.into-you.co.uk

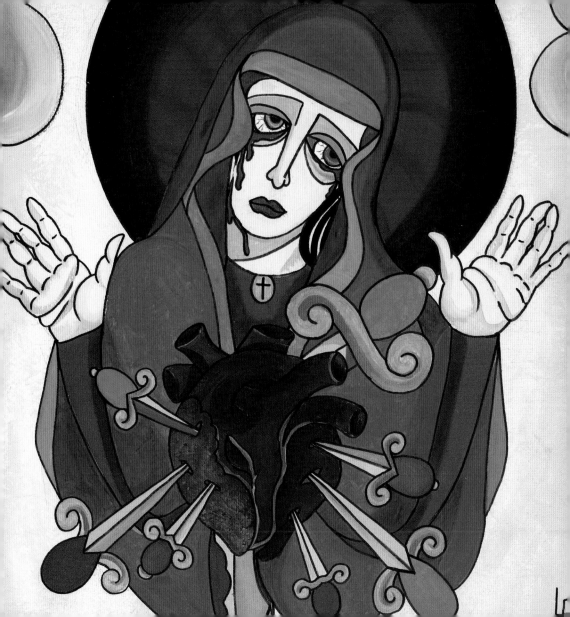

Above left: **Red Mary** *Screenprint on paper.*
Above right: **Black Jesus** *Screenprint on paper*
Below right: **Lady Assisi** *Acrylic on wood*
Opposite: **Veiled Lady** *Pen and ink on paper*

Robert
Ryan

Robert Ryan is a native of New Jersey where he grew up in a house apparently haunted by Eugene O'Neill. O'Neill's daughter Una, who married Charlie Chaplin, was the house's previous occupant.

He has been tattooing for 12 years and works at the Electric Tattoo studio, Bradley Beach, New Jersey, where he is also part-owner. He had several jobs before taking up his apprenticeship at Body Art World, where he was taught in the classic traditional American style of bold outline, strong shading and solid colour. His previous jobs include working as a construction worker, parking lot attendant and dishwasher. He got his first tattoo at sixteen and by eighteen knew he wanted to take it up himself.

He describes tattooing as 'the age-old application of emblematic power symbols' and his personal artwork as 'occult'. He works mostly in ink, watercolour and gouache. Tattoo art and imagery is also always present in his personal work. When asked whether he finds his personal artwork more creative than tattooing, he replied:

I wouldn't say more creative, but a lot more expansive. I don't paint subject matter that I can't personally resonate with. In tattooing I make tattoos all the time with which I have no real deep connection. In those moments I try to just resonate with the craft and application of tattooing.

With a background as a musician, his artwork is unsurprisingly heavily influenced by music as well as poetry. He lists his other inspirations as ancient and esoteric vocabularies, social and natural surroundings, ghosts, muses and frequencies.

The tools and knowledge of the esoteric, occult and invisible belong to us, and should be taken back by any and all means necessary. All division within gender, race, religion and class is made possible through the suppression of true knowledge of ourselves, where we have come from and, even more importantly, where we are going.

www.sanitaryelectric.com
www.myspace.com/americancloudsongs

Above: **The Devine Ashvin Twins** *Ink and gouache on paper*

Ark of the Holy *Ink and watercolour on board*

Our Lady *Ink and watercolour on board*

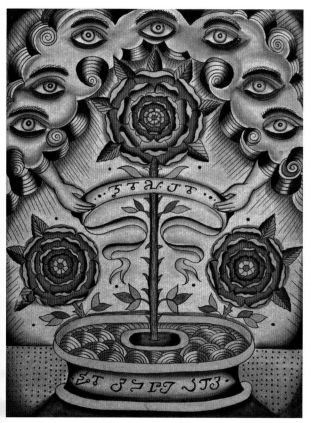
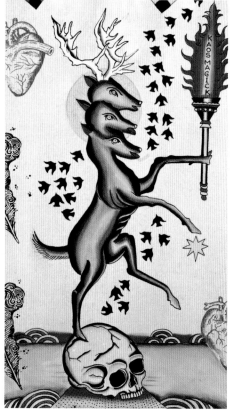

Above left: **Peace Be Unto You** *Ink and watercolour on board*
Above right: **Kaos Magick** *Ink, watercolour and screen print on paper*

L ina

Stigsson

Lina Stigsson is originally from Sweden, but has been living and working in Amsterdam for over ten years. She first came to the city in 1997 to study art at the Rietveld Academy. She got her first tattoo at the famous Hanky Panky tattoo studio when she arrived in Amsterdam. It was after graduating that she started her tattoo apprenticeship. She has now been tattooing for six years and works at Admiraal Tattoo Studio.

I can't really say the moment when I realized I wanted to be a tattooist. It was probably always there in the back of my mind. There are so many things I love about being a tattooer; I enjoy making designs together with my customers and meeting interesting people.

Tattooing is a big inspiration in her personal artwork. Her favourite things to tattoo and paint are girls – particularly old-fashioned circus sideshow ladies. She mostly uses oil paint for her paintings, but likes to use watercolour when she produces flash sheets as the effect is more like tattooing. She gets a lot of her inspiration from her friends and the people she works with.

The difference when I make a painting is that I don't have to worry about how it's going to look in twenty years. A good tattoo has to be done so that it still looks good over time. When I work on my paintings, it's just me and the canvas. I think that's the biggest difference from tattooing, when you are actually designing something specifically for someone. I'm really happy to be able to pursue both tattooing and painting since I like to have variety in my work.

www.myspace.com/linastigsson

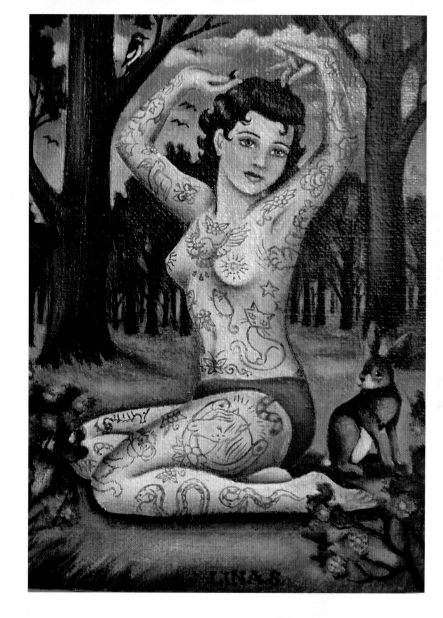

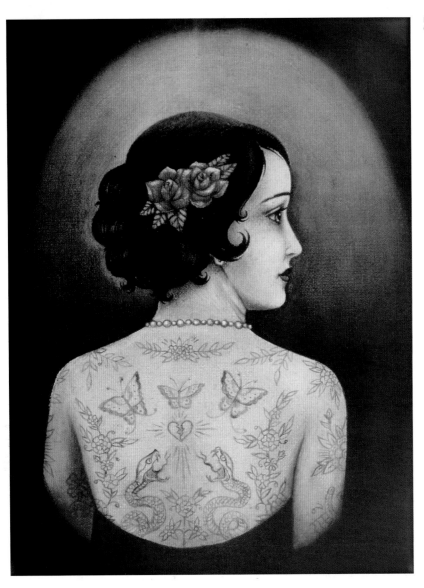

Left and opposite: **Untitled works**
Oil on canvas

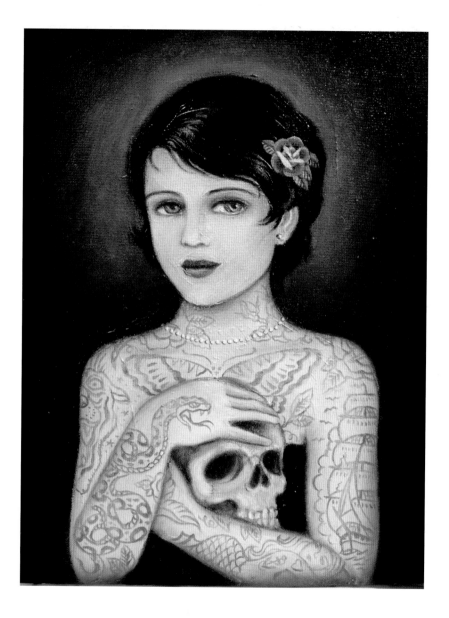

Sumo

Sumo is originally from Nottingham, UK, and has been tattooing for 12 years. He is now based in Birmingham, UK, working at Modern Body Art alongside owners Matt Hunt and Jo Harrison.

Sumo has no formal art or tattoo training, and is self-taught in both. But he did work closely with experienced tattooists at the first studio he worked for in Nottingham.

I knew I wanted to be a tattooist when I started getting tattooed. I was always into art as a kid, so I guess it was an obvious direction for me. I'm pretty lucky as I work with some very cool people who are great artists. I love the fact I'm doing art every day.

Sumo mostly works in watercolour, but has recently started experimenting with oils. His artwork is inspired directly by tattooing and tattoo imagery. And his paintings are usually made in the same style in which he tattoos, although of the two he finds painting a more creative experience:

With tattooing, to a certain degree, you still have to produce an image that the customer wants, whereas my painting is almost always of an image that I wanted to draw or paint. I get influences from all over; anything that catches my eye gives me an idea, although a lot of the time I get ideas from designs I sketch for tattoos.

www.myspace.com/tattoosumo1
www.modernbodyart.co.uk

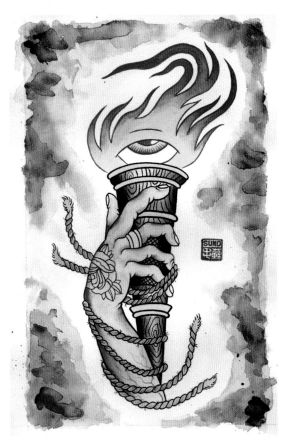

Liberty Torch *Watercolour on paper*

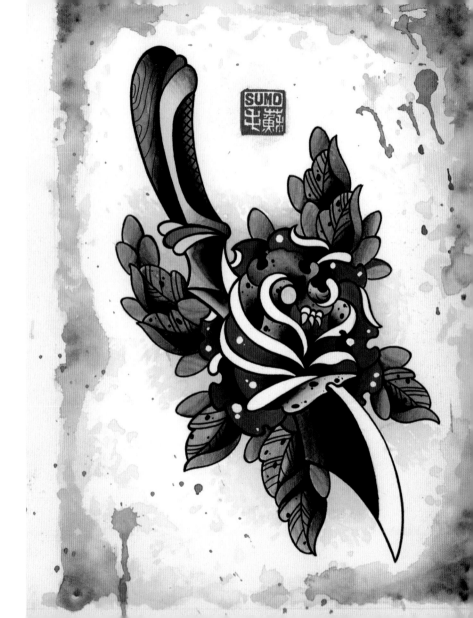

Dagger Rose
Watercolour on paper

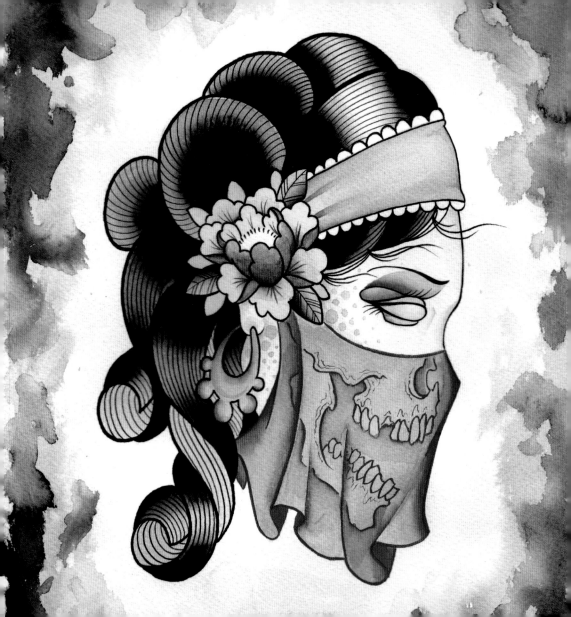

Right: **Black Knight**
Watercolour on paper
Opposite: **Veil of Death**
Watercolour on paper

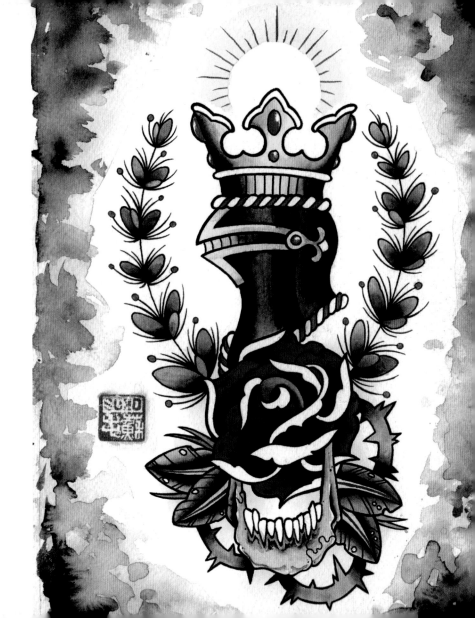

Steve
Whittenberger

Steve Whittenberger is based in Fort Lauderdale, Florida, where he works at Rock-A-Billy Tattoo in Lauderhill.

He has been tattooing for six years, but has been drawing and painting for as long as he can remember. Before becoming a tattooist, he worked in a record store and played in bands. He got his first tattoo at eighteen and started tattooing at Tattoo Art in Billings Montana where he grew up, under Buz Bailey and Jake Kelley.

During my teenage years I really got into tattoo art. I had friends who tattooed and it seemed like what I needed to do. I'm in love with tattooing. I have the best job in the world. I love the freedom, the travelling, meeting new people, the history, everything. Tattooing is the best thing ever.

His personal artwork is influenced by traditional tattoo imagery, as he's mostly inspired by tattooists and tattoo art. He uses watercolour and liquid acrylic; he experimented with many different media, and decided these worked best for him.

Tattooing and my artwork go hand-in-hand. My paintings are basically inspired by my tattooing work and I get to tattoo the things I do because people see my artwork and want it tattooed. They seem to balance each other out nicely. There's not really any meaning or deep symbolism behind my paintings. I paint what I like and do it because painting makes me happy and relaxes me. I do things that I hope people will enjoy.

www.myspace.com/tattoosbysteve

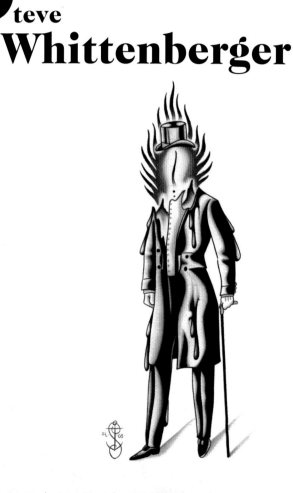

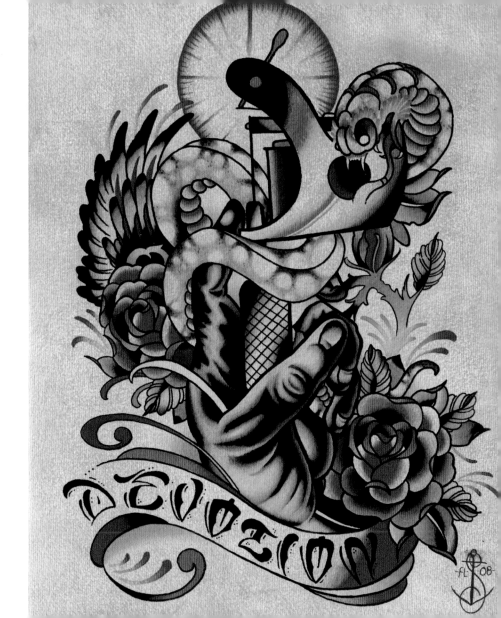

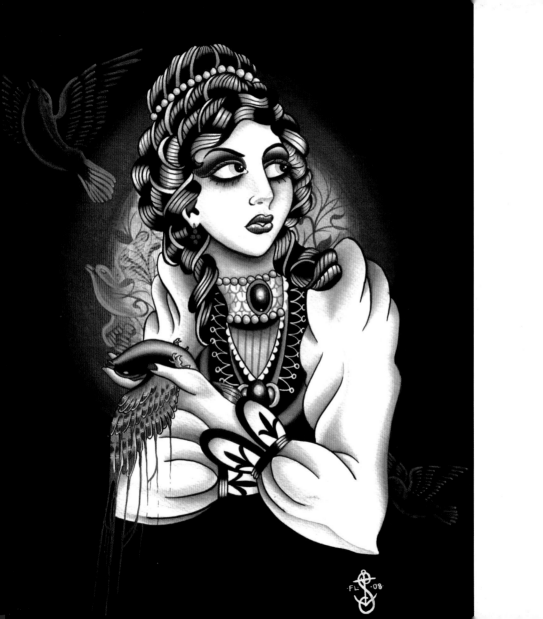

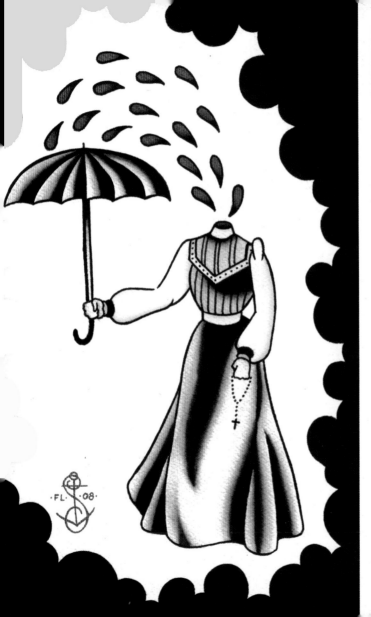

Above: **Coffin Girl** *Watercolour on paper*
Left: **Raining Blood** *Watercolour on paper*
Opposite: **Bird Lady** *Watercolour on paper*

J ames 'Woody'
Woodford

James 'Woody' Woodford is from Brighton and works at Into You's Brighton studio. He has been tattooing professionally since 2003, but to learn the craft had been tattooing himself and close friends since 2000. He had his first tattoo aged only sixteen after becoming fascinated with tattoo culture. It was on that day he knew he wanted to be a tattooist.

His personal artwork is all related to tattooing in some way, and he works in a variety of media, including pen and ink, watercolour and 22-carat gold leaf.

I would describe my personal artwork as 'stuff I like'. It all relates back to tattooing, as that's my driving passion. But I always paint what I want, then see how it filters eventually into the way I tattoo. I probably find my sketchbook the most creative outlet – that's where everything starts.

Woody's influences range from historical events and old paintings to comics and film. Some of his favourite artists are Mark Ryden, Simon Bisley, Mike Mignola and Lars Uwe.

One of the things he loves about tattooing is being able to work closely and on a personal level with his clients:

You really get to know them, almost like family I guess. I also love seeing people's faces when I show them their drawing/tattoo for the first time; it's always a great honour to be able to draw what I like on someone and to have them like it too.

www.woodfordtattoo.com

Above: **Dead German** (detail)

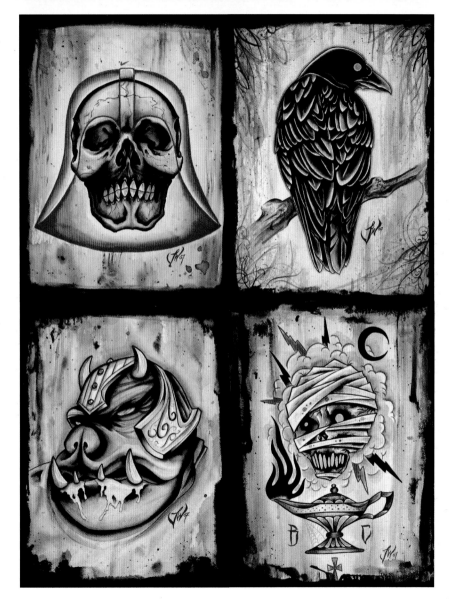

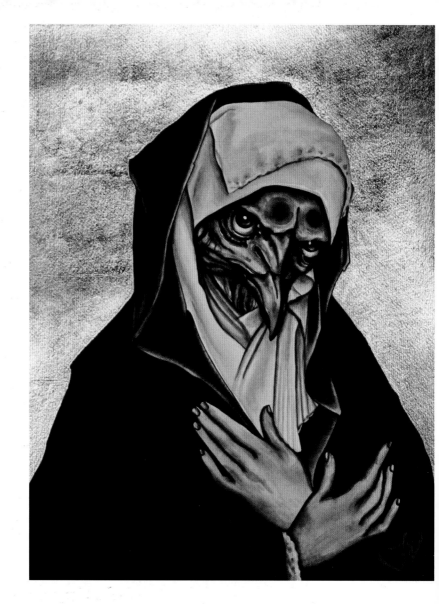

Bird Madonna *Ink, watercolour and gold leaf on paper*

Skull *Ink, watercolour and gold leaf on paper*

Michele Wortman

Michele Wortman lives and works in her home state of Illinois alongside her husband Guy Aitchison at their private, invitation-only Hyperspace Studios.

She has been tattooing for ten years and decided to become a tattooist when she realized that the 'look' she wanted for her own, personal tattoos was not available and had to create it for herself. She apprenticed indirectly under Guy Aitchison at the many tattoo conventions they attended together. Before becoming a tattooist she was a fine-arts painter and a hairdresser.

I had a very personal transformation from being tattooed, assessing my collection and how I was expressing my creative process as a whole. When I began to ponder what I was trying to say through my tattoo collection, everything opened up and a new direction as an artist and collector emerged. Not only did it motivate me to become a tattooist so that I could better express this vision, but it infused all of my interests – taking them in a fresh, new direction. The tattoo work that I do is very specialized. My clientele is almost exclusively female and many of the women who collect work from me are getting what I like to call body sets. This is a custom-tailored aesthetic that considers both sides of the body as one overall look.

Her artwork is very much in line with her tattoo style. She describes it as visionary and colourful with a sense of magic, wonder and celebration. She is a multimedia artist and works across many different media and disciplines including oil paints, photography, computer design and writing electronic music.

I find them equal in their own way. They are all outlets of my creative expression; these media that I pursue are in continuum with the last project/process and relate very much to each other. I enjoy the exchange that each medium offers one another. It is all an act of creativity that expresses the same energy regardless of the medium I use.

Michele's inspirations and influences include spending time in nature, surrounding herself with uplifting and beautiful experiences and taking pictures, which she then applies to all the different media she works in.

www.hyperspacestudios.com

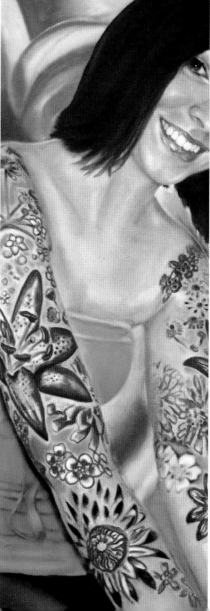

Far left: **Breeze In** *Oil on canvas*
Left: **Nicole** *Photo-painting: oil on canvas*

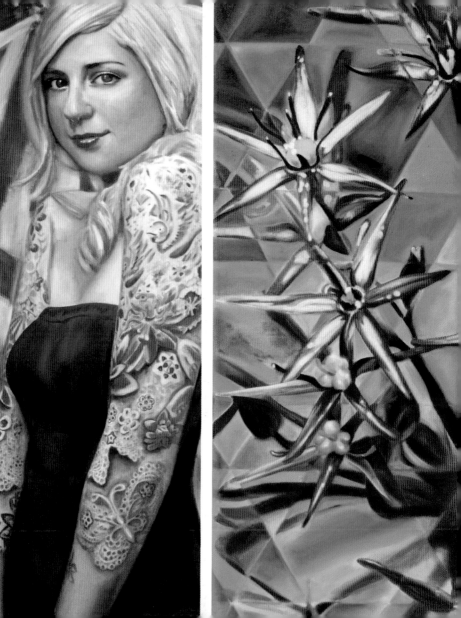

Right: **Mindy** *Photo-painting: oil on canvas*
Far right: **Of Stars** *Oil on canvas*

About the Author

Jo Waterhouse is a freelance writer interested in many areas of art, including lowbrow, street, skateboarding and tattoo art. She is the author of *Concrete to Canvas: Skateboarders' Art* (2005) and *Concrete 2 Canvas: More Skateboarders' Art* (2007) and regularly contributes to several websites and art magazines, interviewing a variety of international artists.

www.jowaterhouse.blogspot.com
www.concretetocanvas.co.uk

Thanks

My thanks and appreciation go to Guy Aitchison, Daniel Albrigo, Mandie Barber, Erik Von Bartholomaus, Chris Bourke, Carnie Marnie, Clifton Carter, Dalmiro, Nate Diaz, Lola Garcia, Gillian Goldstein, Regino Gonzales, Angelique Houtkamp, Matt Hunt, Chance Isbell, Jondix, Jason d. Leisge, Leon McCormick, Cody Meyer, Derek Noble, Lucy Pryor, Robert Ryan, Lina Stigsson, Sumo, Pam, Pete and Kris Waterhouse, Steve Whittenberger, James 'Woody' Woodford, Michele Wortman, and to Jo Lightfoot, Donald Dinwiddie and all at Laurence King Publishing.